African Spirituality

MARIE LAVEAU
LIFE OF A VOODOO QUEEN

MONIQUE JOINER SIEDLAK

Oshun
Publications

Cover Design by MJS

Cover Image by daemon-barzai@depositphotos.com

Published by Oshun Publications

www.oshunpublications.com

Books in the Series

Contents

Introduction

There is much debate about the life of Marie Laveau and her matriarchal relationship with Voodoo. Many people wonder whether or not her life was fact or fiction. She is a prominent figure in American history, infamously depicted as the woman who dances with a snake. If you look at portraits depicting her, you will see a woman of color, clad in white and with a material wrapped around her head, almost looking like a metaphorical crown. She was regal despite being wrought with controversy.

Mysterious and ominous, her life was disputed and wrought with rumors and gossip. Not only was she a person of color, but she was also descended from a mix of cultures. From French to Native American, Marie's most prevalent and notable heritage she displayed was that of her West African roots. West Africa is where our story begins. It starts with the Africans being shipped away and trafficked due to the slave trade that dominated the mid-17th century.

Marie would never have arrived in New Orleans if it wasn't for the Transatlantic Slave Trade and its historical consequences. In the following few chapters, we will explore a complex timeline that will follow, as closely as possible, the

effects of assimilations and African Diaspora. These quick yet simple overviews will be invaluable to understanding the political climate Marie Laveau grew up in. As well as serve as an exciting background for the woman who most likely changed the face of Voodoo for good.

Voodoo is a complex belief system where myths and legends rarely can be explored at their fullest capacity. This book is about the woman who boosted the religion into the mainstream and cannot be discussed without some history. It's crucial to set the scene, essential to dissect the tiny and large details like that make up the path of Voodoo, Marie, and the historical roots of the Queen of Voodoo herself.

Sit back, relax and take a trip from the dark past to the events that created the now vibrant and beautiful Crescent City that birthed the now infamous Marie Laveau.

The City of New Orleans and its Ties to the Transatlantic Slave Trade

THE TRANSATLANTIC SLAVE TRADE WAS A HISTORICAL EVENT that shook the world. It's had a devastating impact on the identity of numerous ethnic groups. It is the leading cause of cultural erasure. Unfortunately, that makes it difficult to find any available information on their true roots. Record keeping of enslaved people was the last thing on the minds of those responsible for the transportation and trade in human life. This is one of the reasons it is so difficult to find information on Marie and probably why her life is shrouded in myth and rumors. But let's not get ahead of ourselves and instead start at the beginning before Marie was even born.

The cause of the slave trade isn't as cut and dry as it seems. It's not complex either. The most significant factor to consider was that, at the time, the Europeans and American colonists needed cheap labor. They had spent most of their time in the Americas wiping out the indigenous people, which included bringing along European-specific diseases. They created an environment that forced them to 'outsource' the labor necessary to run their established businesses. Majority of the businesses being sugar cane, coffee, and cotton plantations. The only option that seemed to have any appeal to these busi-

ness owners was to tap into the already thriving slave trade at the time (Lewis, 2018). While Europeans are the biggest culprits in the transatlantic slave trades, they did not participate in the oppressive practice without help. African kingdoms and Arabic merchants were already trading humans since as early as the year 900 (BBC, 2019). By the mid-17th century, hundreds of people were trafficked and dumped in the Americas to control the cotton, coffee, and sugar plantations established there by European colonists. With the Arab, African, and European merchants now happily trading human life, there was no shortage of cheap and reliable labor for these plantations. From the Spanish to the Dutch and the French-owned settlements, most slaves bought and traded mainly from the West African region. It is theorized that the majority of slaves were of West African descent, mainly Yoruba, Dahomean, and Kongo people. This factor will later contribute to the evolution of Voodoo in America (The Editors of Encyclopedia Britannica, 2018).

Due to the nature of the slave trade, many people of color were dispersed across the surrounding areas of the Caribbean Islands. This caused dissent from their religious roots. Unlike New Orleans Voodoo, West African spirituality isn't as assimilated with other belief systems. While there is overlap in modern-day Africa, most tribes still leftover hold fast to their oral traditions. Unfortunately, however, in the case of New Orleans Voodoo, any historical evidence on these spiritual beliefs has been lost over time. The domineering religions of current times and past, such as Islam and Christianity, have most likely contributed to the mistranslation of many traditions now used in New Orleans Voodoo. Labeling African beliefs as a "religion" does a disservice and undersell the complexities of the intricate belief system. African beliefs are a mixed bag, so to speak, and present-day Africans experience diasporas due to the nature of the culture being erased or forgotten. In brief terms, it is a spirituality that considers

advice and communication with ancestors, or departed family members, with the highest regards. It is important to receive guidance from the spiritual realm through the use of a blessed representative. This is a big recurring theme in African culture all across the board. In some branches, you need to be called by the ancestors as communicators and advocates or Diviners for those seeking advice on their socio-economic situations. It can be things related to every day, like wealth, partnerships, or even if you just suspect there has been a curse placed on you by an outside party (Wikipedia Contributors, 2019). In the case of the Yoruba tribe, the belief in a supernatural deity known as Olodumare is the Supreme Being, and many Africans don't directly communicate with this deity. This is what you need the Ancestors for—to speak on your behalf. In the African tradition, it is also vital to incorporate music and rhythmic dancing to deep spiritual connection to that of the realm of spirits and nature. It is a sign of coexistence and respect among those of African descent. Numerous rituals are imperative to the developments of the supernatural and the everyday life of the African tradition. In African spirituality, it is important to honor and respect your ancestors. This overview of African spiritualism is crucial as eventually, it will translate into the background of New Orleans Voodoo. Unfortunately, due to the mass demonization by the reigning religions, a common misconception is that these practices are evil and satanic. In reality, it is just a colonialist view on a perfectly normal and traditionalist belief system. A system created by an ethnic group who shared these rituals and stories orally among themselves and cared for and respected their roots and culture.

Birth of the Crescent City

The book has yet to reach the tumultuous history of Marie Catherine Laveau. Mainly because the stage for her life must

still be set, the backdrop to be painted, and the environment expanded. The landscape in which she grew up was appropriately named Crescent City, New Orleans. The vibrant, colorful, and diverse New Orleans, Louisiana. The jewel of cultural assimilation in the United States. The mixed bag of culture that thrives in the Crescent City has always been admired and seen with contempt by historians alike. New Orleans is known best for its nightlife, with parties that last far into the morning. People go there to get Voodoo spells and participate in debauchery. They also go there to reach spiritual fulfillment and drink in the essence of the city. However, it is indisputable that the city has developed its own traditions and culture, and sub-culture of Haitian Voodoo. The New Orleans variation of Voodoo didn't just rain down from the sky to establish itself as the cultural hub it is known for today. No, instead, it originated a bit further away from the Louisiana city.

In the mid-17th century, many African slaves had ended up on small islands, known as the Caribbean Islands (Haiti - Climate, n.d.). One such island was Haiti. Pre-contact Haiti was first 'discovered' by the infamous Spaniard Christopher Columbus in the 1400s. He took it upon himself to rename the small island he anchored upon Hispaniola—Little Spain. This was one of the first Spanish settlements before being annexed by the French, who renamed it Saint-Domingue. As time went on, Roman Catholicism prevailed as the main religion, which automatically banned any other form of religious freedom. Many people of color, natives, and slaves alike, were forced to convert (Lewis, 2018). This sort of environment was the perfect recipe for creating turmoil among the Haitian citizens. It was a life driven by hardship and dominated by laws of oppression. Designed to stifle and discourage the people's customs, laws were passed that banned any display that wasn't up to the standard of the domineering religion. These included but were not limited to rhythmic dancing, interracial partnerships, and marriage. Luckily, if one could say that,

African spiritualism is easily assimilated into most religions because it isn't a written form of spirituality.

Catholicism prides itself on its meticulous record-keeping, training priests and scribes to translate and re-write biblical texts. It has a strict set of rules and regulates the way people worship God. African spiritualism relies more on word of mouth, having a history of oral tradition. It is no surprise then that the first practice of Voodoo originated from a Catholic settlement and soon started to spread. It was an easy action to merge African spirituality with Catholicism. That way, the ethnic groups could still partake in their personal rituals. It was a clever loophole, but it wasn't going to last long. Especially after the Saint-Domingue Revolt. The fact that despite this loophole, the French still didn't appreciate any form of religion practiced in a way they disapproved of, and this was one of them (McAlister, 2018).

Haitian Vodou might be the foundation on which present time New Orleans Voodoo is based. Still, it has its own history, and it's crucial to differentiate between the two. After all, how do you discuss the Voodoo Queen if one does not even understand the brand of Voodoo she most likely partook in. 'Vodou,' as known in Haiti, is a loosely translated Fon word for 'spirit' and predominantly involves the communication and involvement of ancestors and beings known as Lwa. These beings or entities are known to run the world's natural order, and Vodou recognizes the importance of the Lwa. Followers willingly participate in festivals and spiritual rituals to summon and communicate with these entities. Much like the Greek pantheon, each Lwa has a role in the physical realm apart from its supernatural realm. Some deal with economic status, or some offer advice during a difficult time, while others are set to have a tiny bit of control over the natural elements. Through priests, dance rituals, and prayer, a Lwa can be summoned to embody a host. This is often referred to as a spirit riding alongside the host. Oddly enough, though

frowned upon and classified as possession, there is an almost direct correlation with how the Catholic church emphasizes the importance of the Holy Spirit. The Holy Spirit is an abstract, omniscient being that offers itself as a spiritual guide to Catholics. Both the Holy Spirit and the Lwa are presences that fill a willing host with its presence. Providing its wisdom and guidance as a way to traverse life for the worshipping patrons. It sets it apart because you do not give the Holy Spirit entity-specific offerings that might entice you to the physical plane in Catholicism. Catholicism isn't shy towards idolism, and this is cause for much disagreement with various other Christain denominations. Perhaps this is why the people taken as slaves could quickly adopt the near basics of the faith.

Catholicism might also not have been the only influence on New Orleans Voodoo.

While the practice of Vodou was most likely an act of rebellion against an oppressive colonialist regime, it still took on the influences of numerous religions and traditions. While West African spiritualism is the most significant influence, tiny Native American practices weaved into Voodoo. Much like its African roots, Voodoo also reveres respect for nature. They understand that there is life in all things and that it has power. These topics are essential to further explore the rituals and customs used. Later in the book, they will be discussed alongside potions and gris-gris crafting.

At this point, the question on most people's minds might be, how did this syncretic religion end up in New Orleans? How did Marie Laveau end up as its most prominent advocate, rising to almost mythical status? Simply put, the Saint-Domingue revolt. The revolt was a direct rebellion against the oppressive french regime and the prevalent racist and classist discrimination. While many factors led to the insurgency, it was a successful revolt. It contributed to more people of color dispersing further away from the island of Haiti.

During this time, the City of New Orleans was commis-

sioned and unofficially founded by Jean-Baptiste Le Moyne de Bienville (Jackson, 2019). It was set to be a port for the depository. Plans for New Orleans were started around March 1718, just as the revolt began, which was the following year of 1719 (The Editors of Encyclopaedia Britannica, 2021). Many slaves at this time were migrated to the new and growing settlement, perhaps as a way to placate the locals from rising up against the plantation owners. Unfortunately, it didn't go as smoothly as they had hoped due to the environmental and political climate, and not all was well. The new settlement was strife with hurricanes, a lack of supplies, and internal conflicts between the forced laborers and colonists. Eventually, after much struggle and notable setbacks, the first crude beginnings of the city were officially established around the year 1721 (Jackson, 2019). Its first settlers were a mixed bag of Canadians, troops, slaves, and prostitutes. Two sub-ethnic groups also started to arise from this melting pot of people called the Creole and Cajun. The Creole people were usually those of French/Spanish descent, mixed with West African roots (Creole | People, 2019).

They were often kept from high positions of power and jobs. The Cajun are European-Canadian descent and were known to have settled in nearby swamps, considered the promptly named The Bayou (The Editors of Encyclopaedia Britannica, 2019). The Cajuns were Roman Catholic believers forced there by the British Empire who ruled during that time. These tiny and significant contributions will be the foundation on which Crescent City is built. Soon, its own personalized branch of Voodoo will be born. A good distinction between knowing is that there is a difference between Vodou and Voodoo: one is tied explicitly to African Spirituality. The other is what we see in New Orleans today. It is different due to its diaspora merging with the Catholic religion. The Voodoo that most of us know today is the Voodoo constantly stereotyped in Western media as the 'zombie and straw doll' religion.

Vengeful curses and over-exaggerated dress with priests and priestesses playing with the lives of the innocent. It displays a gross and inaccurate representation of religion with such a historical background (History of New Orleans Voodoo | New Orleans, 2017).

Christianity and Its Effect on New Orleans Voodoo

New Orleans was a newly developing city. Like its other French and Spanish predecessors, it readily adopted the dominant religion—Catholicism. It made sure to plant its roots firmly in the soil and contributed to the system followed today.

Christianity is one of the three dominant religions globally and doesn't just have one denomination like many other belief systems. From the more Conservative Protestant to the Spirit-Centric Pentecostal, Christianity has become more than just a term for followers of Jesus Christ. It has instead taken on an umbrella term as its central identity. In the case of New Orleans, it was the Roman Catholic faith that dominated the city. It makes perfect sense that this belief system assimilated with that of the Haitian Vodou. It bears a few similarities with the importance of spiritual communication and repentance for sins—or bad things—to improve external factors of one's life. Much like Vodou, in Roman Catholicism, the need to go and see a priest is vital in trying to gauge the current supernatural state of your life. This priest or diviner will then commune with the entities that control the mystical realms and give you instructions on relieving your external circumstances. Vodou also adopted the practice of exorcisms and bestowing blessings on the physically ill. Fascinatingly enough, it's almost symbiotic in the relationship (History Of New Orleans Voodoo | New Orleans, 2017).

This doesn't, however, deter the criticism and backlash it has received from orthodox groups. Voodoo itself is seen as demon worship, and the rituals needed to improve the way of

life are seen as satanic. This, unfortunately, results in Voodoo becoming part of the Paganism term, which does it a disservice.

Perhaps the problem is the lack of understanding regarding the spirits that inhabit the realms of the supernatural and their goals in the tradition of Voodoo? Before taking a look at Marie and her incredible life, a trip through the lives of Voodoo entities is in order. It will provide clarity over misconceptions and help with further understanding of Marie's life growing up around Voodoo (Times-Picayune, 2018).

TWO

Deities, Spirits, and the Divine

In Voodoo, spirits and deities are summoned and spoken to by diviners. Still, not just anyone is bestowed the honor of speaking to them, as Voodoo practitioners call Lwa. There are many Higher Beings in Voodoo. While they all differ in variations and versions, a few key figures in the Voodoo religion are necessary and more popular in modern-day practice. It is these spiritual beings that have dominated the world before and after Marie's death. To follow a tangent for a moment, I thought it interesting to look at these important critical figures of Voodoo and see what they represent to the practitioners of the religion.

Papa Legba

One such spiritual being is a ginen by the name of Papa Legba. Guardian of the Crossroads, Papa Legba with his crutches, smoking pipe, and a brimmed hat (Wikipedia Contributors, 2021c). He is often depicted as an old man and is said to be summonable using an incantation. It goes as follows:

'Papa Legba, Open the gate for me/Atibon Legba, Open the gate for me/Open the gate for me/Papa that I may pass/When I return I will thank the Lwa.' (NPS, 2015).

He is the great communicator between the human realm and the spiritual realm as he speaks all languages. He is said to either grant or denies the ability to talk with one's ancestors. Allegedly, no spirit may enter a host's body without Papa Legba's permission. It is important to give him the respect he deserves and not overlook his crucial role in Voodoo. He is the one that stands at the spiritual crossroads, most likely judging whether or not one should be granted access into the sacred spiritual world. It's the advice of many practitioners to not seek out that which you do not understand and to proceed with all future rituals with caution (Wigington, 2019a).

Papa Legba also has another Lwa that can appear once he has been summoned. She is one of the more common deities and also his wife. Her titles are as such—Mambo Ayizan, Mrs. Legba, or the Queen of the Marketplace. She is known to show up with an entourage of spirits and blesses those who are owners of the business, passing on sacred knowledge of the deep spirit world. Ayizan is also known to help those who are oppressed and curses those who lie and are exploiters of the innocent. When summoned, she is to be revered and respected, like all Lwa, and it is wise to offer her white flowers and sweet liquors (Wigington, 2019b).

The Supreme Being

The Supreme Being goes by many names and, as previously mentioned, is also a significant figure in the Voodoo religion. This being or god isn't known to involve themselves in human affairs. It is why there is such insistent importance on the Lwa. Most likely, Marie used spiritual channels, such as Papa Legba, to receive clarity on her client's needs. Whether it is

God or the Creator of the world, like in the West African religion, The Supreme Being is the overseer of everything. The majority of people, if not all, are not worthy to face the deity and be in its presence. Instead, they need the Saints and ancestors to advocate for them using a chosen few such as; diviners and priests. The role of the Supreme Being is the very reason why a practitioner's relationship with the Lwa, or spirits, should be of the utmost importance.

Death Spirits

Marie and other practitioners might have been in contact with other spiritual beings that would have been either Maman Brigette or Baron Samedi. Often depicted with his top hat and skeletal appearance, Baron Samedi is an entity that leads the ghede, Lwa, with specifically magical ties and bonds. His role, however, extends beyond that because he is also the spiritual equivalent of border control for passing spirits. Both he and his consort, Maman Brigette, control and police the barrier of the spiritual realm. Making sure that proper rites are obeyed and that the spirits crossing over to the other side are worthy of such an honor (Wigington, 2019b).

These two deities, related to death and old ancestors, make sure heritage and history are protected and passed along accordingly. They prevent souls from re-entering the bodies of the dead and becoming zombies, as well as striking deals with the living. Additionally, Baron Samedi is also the spirit of debauchery and resurrections. Constantly depicted as wicked, and when asking for a price from the living, one would hope that he is in a good mood. Maman Brigitte is the wife of Baron Samedi, and often she is portrayed as a fair-skinned woman with red hair having a stark contrast from her husband. An interesting fact about his mate, Maman Brigitte, is that she could have been descended and created from the

Celtic goddess of hearth and domestic life. Brigid is known to be the daughter of the father-figure god, Dagd. She must have made her way from Scottish and Irish roots to that of Haiti. Only Baron Samedi is said to be able to accept a soul to the realm of the dead with his consort at his side (Wigington, 2018).

More Spirits and Deities, Including Quick Descriptions

Having covered the three most notable entities in New Orleans Voodoo, here are some other spirits and deities, including fascinating information on them and their important qualities (Jan & Webster, 1990):

Adjasou: Lwa with protruding eyes, favoring the tastes and smells of vermouth, rum, and cognac.

Agassu: A Lwa mason that represents the union of a woman and a panther. Dahomey in origin, including an association with the Yoruba and Fon tribes. A person being ridden by him tends to have crooked hands that have stiffened in relation to his appearance.

Gran Boa: Protector of wildlife and known to eat only fruits and vegetables. Called upon when one gets ordained into Voodoo priesthood.

Azacca or Zaka: Favors offerings of boiled maize, unrefined sugar, and white rum. Seen as the brother of Ghede, he is the Lwa of agriculture. Zaka tends to be suspicious by nature and is quite fond of the latest gossip amongst people. Unlike his brother, Zaka is seen and depicted as less serious and is usually out for profit. He is a polygamist, and each child he has is seen as a business opportunity.

Ghede: Spirit of Death, and much like Papa Legba, he controls the crossroads of the afterlife. Oddly enough, he is also the Lwa of eroticism and can be summoned by performing a dance that imitates the step of intercourse. He is

more amused by humanity's obsession in pretending the existence of eroticism is everything it's not. Another name for Ghede is Baron Samedi.

Kalfu: Not liked much, but respected—this Lwa is the counterpart to Legba. He has access to the off-center points of the crossroads and is known to control the evil spirits. Some claim he is a demon in disguise, but he denies this. Origin of darkness and most likely why the world is in constant chaos, Kalfu is known to enforce injustice, bad luck, and deliberate destruction. Additionally, he is the Lwa of black magic and charms.

Ibo Lele: Independent and a jealous Lwa, who needs to be exclusively followed. There is no uncertainty of what food offerings to provide to him.

Obatala: Sky Lwa, responsible for forming children in the womb and thus directly tied to birth defects. His followers are known to wear white.

Ayizan: She is the wife of Legba and protector of public spaces. She has deep knowledge of the intricacies of the spiritual world and is known to call upon and choose novice priests to pass on her knowledge. Often depicted as an old woman and only manifests once her husband has shown up.

Marsasa: These are twins who died in early childhood and represent innocence. Among other things, they eat food provided to them until they are full and happy. They then listen to the patterns who summon them and punish those who do not finish the food offerings.

Loco: He is a God of healing and is said to be invoked by doctors before they offer any sort of treatment to their patients. He watches over sanctuaries and temples, and his appearance is akin to the art of nature. Additionally, he is also called upon as a judge since he despises injustice.

Agwe: Invoked under the names' Shell of the Sea, Eel, and Tadpole of Pod.' He is the deity of the sea and protector

of seafaring men. Symbols include but are not limited to painted oars, shells, and tiny boats. A conch shell can be used to summon him during Voodoo rituals, and be sure to make sure that the host who has been taken over by him doesn't jump in bodies of water. Correlates with the Catholic Saint, St. Ulrich.

Dumballah: He is the great serpent god and is often seen as benevolent and a father figure to his patrons. He radiates positive energy when invoked and can also be the symbol of fertility. Commonly referred to as Da, he and his wife Ayida represent human sexuality.

Ayida: Counterpart and mate of Dumballah. She is submissive and delicate, and along with Dumballah, they are a unitary force in human sexuality. Her primary job is to hold up the earth as she serves as a mother figure.

Agua: Violent deity of thunder, storms, and earthquakes. Those who aren't strong enough to hold him when possessed can end up dead or seriously injured. Known to use the host to utter the words, "It is I who am the gunner of god; when I roar, the earth trembles."

Sogba and Bade: Lwa of lighting and wind. Used to summon Agua and cause a thunderstorm. Sogba and Agua are inseparable companions.

Linto: He is a child spirit in the Ghede family. When summoned, he has the host take on childlike attributes such as clumsily stumbling around and crying for food.

Ogun: Warrior Lwa, with mastery in blacksmithing and known to protect those who summon him from violence. He uses prophecy and magic when petitioned and is rumored to have assisted in the Slave Revolt of 1804 in Haiti. Ogoun is a well-respected Lwa.

Siren and Whale: Marine divinities that are always worshiped together and usually featured in the same songs. They are traditionally viewed as more noble and upper class.

Sobo: Lwa of strength and protection. He is significant to

the Voodoo religion. When summoned, it is suggested to be in military gear as Sobo will use the opportunity of possession to address the audience in a militaristic, forceful way. The patrons who petition Sobo will be protected from wild spirits, and he is also said to have the power of healing.

Marie's Early Years and Personal Life

ALL OF THIS AND MORE IS WHY PEOPLE LIKE MARIE LAVEAU are relevant to the evolution of Voodoo. Not only is she a woman, but a woman of color. Her popularity should have been unheard of during times of intense racial tension between black and white people. From the brutality of slavery to the caste system implemented by the French, a system that has done nothing to benefit the modern society that people are currently living in. While it wasn't expanded on in the history section of the book, a quick detour is in order. The caste system was implemented as a means to create segregation and cultural divides. It follows a complex law of hierarchical division amongst people to keep them separated from each other. Sometimes, this is concerning color. Marie Laveau and others like her could only hope to improve the livelihoods of those around them. Traversing the dangerous and sensationalist city she lived in, systematically taught to watch people like Marie with an eye of judgment and speculation. It is time to explore the woman who assisted in changing the opinion of Voodoo forever.

Sultry, charismatic, and seductively ominous Marie Laveau. She was said to have eyes that could entrance many

and confidence that spoke more than her words. She was and still is an enigma. People have spent years studying and analyzing her life. Still, as her reputation, the sources are varied and buried deep within the myth. The stage has been set, and the performer is a fantastic female entity that has entranced many people into her web of intricacies. It is time to dive deep into her life and hopefully debunk the mysteries surrounding the almost goddess-like figure of New Orleans. In the following few chapters, using the brief historical overview, we will explore her origin story and deduce what is fact and what is fiction. Starting from her birth and moving to the legacy she left behind and established for the future generation. Practitioners of Voodoo and other Neo-Paganistic believers revere her as a feminine entity of power and protection. Why is that? These are the questions that will be answered. While historical records about Marie Laveau are few and far between, hopefully, it can be better explained with all this knowledge explored.

Who was the Queen of Voodoo? What made her so famous and shrouded in legend that she has even inspired her own character on the popular television show, American Horror Story (Wiki Contributors, n.d.-b)?

Origins Before Her Rise as Voodoo Queen

The introduction of the life and times of the infamous Marie Laveau is set to start, and it begins with her great-grandmother. The latter was reported to be a victim of the slave trade. She was a slave brought over from Africa. Like many of her comrades, she was forced into tedious labor by apathetic plantation owners who have long since become dissociated by the cruelty of their actions. She most likely suffered greatly under the hands of these people who saw her as less than human. It's assumed that she has most likely still held on fast to her familial roots at this point in her life and kept a connec-

tion to her spiritual identity, despite being forcibly removed from her home. And because of the poor record-keeping of the Euro-Americans of the time, we are unsure of her name and history. However, she did have a daughter named Catherine Henry (Dimuro, 2018). Catherine was most likely mixed race. The contributing factor to Marie's ethnicity, who is said to have had some Native American features, despite there never being an official portrait of Marie.

Eventually, as Catherine grew older, she too had a child of her own. She spent years moving from one owner to the other before she ended up in the custody of a free woman of color with her daughter. she worked until she could buy her and her daughter's freedom. Catherine's daughter was Marguerite D'arcantel, a surname adopted from a former owner. When Marguerite grew up, she met and married Charles Laveau. The exact date of their marriage is unknown, and it is often disputed if he was a wealthy white plantation owner or a mixed-race plantation worker.

Nonetheless, the current census is that he was a free person of color. Not much is known of Marie's parents or their lives together. What can probably be deduced is that it would have been a life of controversy and difficulty, taking the social status of New Orleans into account. Undoubtedly, they wouldn't have had much money, as paid labor was a new concept and was heavily exploited and never criticized. Nonetheless, Margueritte and Charles would soon bring a very powerful woman into the world (Lewis, 2019b).

Records of her birth date are often disputed and debated, but Marie was born between 1794-1801. While not much is known about her childhood, there are tiny bits and pieces of the sort of childhood she would have led (Forgotten Lives, 2020). Odds are in a racially segregated city. She grew up in her maternal grandmother's home. Some sources say that it might have been a far-off cottage, and there she spent her younger years under her grandmother's tutelage. It was also

rumored that she hung and played around the plantation her father worked at when not there. It's unclear just how much of a relationship with him she had, but regardless, that's where she was rumored to be. Marie's life is much more matriarchal compared to others. Her great-grandmother and other matri-archal family members had a deep sense of the spiritual background. They were most likely why young Marie was influenced so heavily to explore and learn the arts of Voodoo. An additional common myth or rumor about her upbringing is that the young Marie was the talented apprentice of the one and only Dr. John—a man who was seen as the Voodoo King of New Orleans and as a conman (Vitelli, 2012). Most likely, however, it's only a fabricated tale, and since then, there has been no evidence to suggest otherwise. Alongside her spiritual tutelage, Marie was also given other skills by her family. Her mother taught her the art of hairdressing, and as she grew up, she also picked up skills in salve crafting and learned to be a midwife. These are most likely the reasons she is often depicted as being compassionate. Don't think that Marie was only a practitioner of Voodoo and a woman of the occult. She was also known to be very devout in her Catholic faith. Going to Mass every Sunday and regularly reinforcing her faith in God, only ever offering help to those in need. This directly correlates to the people of African descent having to accommodate a religion forced upon them and is mirrored in Marie's life.

Marie Laveau was beautiful. Even though there is no official imagery of her, she was said to be a striking woman, with dark, alluring eyes and an air of certainty. She carried herself with poise and didn't let anyone tell her what to do. This is possibly what attracted her first husband to her, a time before her reputation even preceded her. His name was Jacques Santiago Paris, and he was a local carpenter that worked in the French Quarter of New Orleans. The French Quarter was often referred to as the Crown Jewel of New Orleans. In

present times, it is usually teeming with nightlife. They were married in August of 1819, and the wedding was officiated by a man named Father Antonio. Allegedly Marie's very own father signed off on the marital papers. Not much is known about Jacques's backstory. Still, his existence in Marie's life has been the source of many questions, especially since Jacques disappeared. Jacques and Marie weren't married long, and although there was a rumor of them having two children, there was no evidence of their births. It was only thrown deeper into a mystery when Jacques vanished. The stories of his disappearance spread: He was a sacrifice for some sinister Voodoo ritual. Marie killed him and used his bones in a potion. He left her because she had taken many lovers and was unfaithful. These rumors were unflattering towards her character and pure sensationalism when perhaps the answer is more straightforward than previously imagined.

The Theory and Disappearance of Jacques Santiago

LSU Archaeological Doctoral student Kenetha Harrington believes that even though it's been fascinating and fun to dream up supernatural causes for his disappearance nearly 200 years ago, there might just be a more straightforward solution to his mysterious vanishing (Louisiana State University, 2021). Harrington theorizes that he ended up in a city not far off from New Orleans. She had already considered that scholars most likely scoured the records in New Orleans, so instead, she started with neighboring cities such as Baton Rouge. She also searched under Santiago Paris alongside Jacques. Unfortunately, she didn't find anything under Jacques or Santiago. Still, in 2019, she did stumble upon records from 1823 that listed some personal belongings that were under the name St. Yago Paris. Was this a coincidence? Harrington didn't think so. St. Yago Paris was a free man of color who also happened to be a carpenter. He also happened to be

living around the same time as Marie. In Harrington's opinion, the dots align. While she is ready to have her theory challenged, up until now, it remains unchallenged. While this isn't the sensational story most people have dreamed up for Paris, there is some solace in knowing that he moved 80 miles upriver from New Orleans. While we don't exactly know why, he died with some tools and from an undescribed illness, eventually buried in an unmarked grave at the St. Joseph Cathedral in Baton Rouge (Overdeep, 2021). Whether Harrington's theory is true or not is still yet to be disputed. But it does seem that her theory is the key to the mystery that has plagued followers and historians alike (Staff Writer, 2021). It probably didn't help the sensational rumors when Marie started to refer to herself as Widow Paris after his presumed death.

FOUR

Career, Children and Jean Louis
Christophe Galpion

As the "Widow Paris," Marie took up a job as a hairdresser. Since women didn't have many viable career options in the 17th century, we can imagine with her husband gone, she still needed to make a living for herself. It wasn't uncommon for widows to pick up numerous odd jobs to make a living, and Marie was not much different in that regard. Her mixed-race gave her small advantages. While it wasn't a massive opportunity, it gave her the option to establish herself. Marie spent her time as a hairdresser. Supposedly listening to the laborers of the elite when they came for appointments. Unpacked the things they had seen and heard while under the servitude of their owners.

On top of that, she had also been catering to the wealthy, white elite of New Orleans, specifically the gabbing wives of prominent political figures. Or so it was speculated. As a hairdresser, she would have been easily privy to the inner workings of the upper class, and this advantage would aid her in her role as the "Queen of Voodoo." As they gossiped and shared, Marie happily gathered up the details of their lives. She would use these secrets later in her life to assisting in private consultations with those same elites (Times-Picayune, 2018).

In these consultations, she gave them advice and spiritual guidance for their everyday lives. During this time in her life, she met and entered into a romantic partnership with an affluent white man named Jean Louis Christophe Duminy de Glapion. Marie and Glapion could never enter into a marriage due to the laws forbidding interracial couples. Their partnership was not too expanded upon and is mostly just rumors. One or two suspected records on their partnership mention their children together, such as the speculated amount of children they had—which is said to be fifteen children despite only seven of the children actually being on record. Unfortunately, only two of Marie's children actually survived into adulthood. The others died due to the terrible and devastating pandemic of Yellow Fever in the city, which was caused by inadequate sewage circulation.

The impact of Yellow Fever was immense, and symptoms included; headaches, intense back pain and severe fever, and in some cases, jaundice, hence its name. It is simply unimaginable losing several children to such an illness. Since modern medicine wasn't yet available back then, she probably had to watch as her children deteriorated away. Maybe this contributed to the good deeds as an herbalist that she would later perform in her life?

Career and Additional Contributions to the City

Despite these hardships and setbacks, Marie stayed a devoted and loving mother, not only to her own children but also to her "spiritual children"—the citizens of the Crescent City. She was said to spend much of her time tending to her followers, consultees, and patrons. Employing her skills in hairdressing and her skills in other abilities, she had lined up on her repertoire. She wasn't just a hairdresser but was also known to be a midwife and an herbalist.

There isn't much on Marie's personal career in herbalism

and being a midwife. Still, it would be nice to do a quick over-view of the two respective careers in the 19th century and what her duties would have entailed. At this point in time, we can use the information on these career paths to deduce her contributions to society.

Midwifery is a skill that was not taught in the 19th century. Yet, surprisingly enough, it fits the bill of Marie Laveau quite well (19th Century Midwives, 2014). Childbirth isn't a walk in the park by any means. Even now, in the 21st century, there is turmoil among people in regards to giving birth. This is nothing new. Frequently, labor is depicted as a woman screaming her way through the pain of bringing a life into the world. Back in the 19th century, this was an even more complicated process due to the lack of medical advancements and knowledge (Connerton, 2012). Histori-cally, midwives had no prior training in how to bring a child into the world. Instead, they were said to have been older women, relatives, and even widows who have borne children previously. Many employed herbs and remedies to ease the woman giving birth through her pain and encourage her through that painful process. It is almost ironic that this prac-tice was not only seen as a lower-class job, but many years prior, it was associated with witchcraft due to the medicinal remedies offered by the midwives. It just shows how the times have affected the evolution of society and culture. This preju-dice was promptly dropped once people realized there was a specific need for midwives and their acquired skills. After all, the fathers of the children weren't about to stand by their wives' sides and watch as they suffered through the complica-tions of birth. With her Voodoo background and knowledge in organic remedies, it's no surprise that Marie ended up as a midwife, and odds are she was a good one. She had a direct line of Voodoo practitioners in her resume and had already been a mother to seven children. In this circumstance, she had to have had a detailed understanding of the birthing

process and how to help the women around her (Davis, 2013).

Her compassion for people translated into many areas of her life. For example, she also tended to the thousands of people affected by the Yellow Fever epidemic. This virus turned the Crescent City into a "Necropolis" or a City of Death.

Marie tended to the citizens of New Orleans, employing the use of herbal remedies, again information is scarce. Still, with some research, it can easily be deduced what those remedies were made of and used for, especially in curing ailments. These remedies also correlated with rumors of Marie being accomplished in faith healing, perhaps influenced by her Catholic faith. Herbalism is tied to African traditional healing and medicinal solution to ailments. Voodoo and African spirituality involve consultation with the spirits that then advise the communicator or diviner what concoction to make to help the ailed individual. It is unknown if this is Marie's process. Still, it is interesting to have some surface-level information on the practice for thousands of years. Traditional healing includes the practice of harnessing the resources nature provides and implementing generational knowledge and those of spiritual guides or ancestors. It is essential to understand that unlike the western view of ailments, in general, African tradition, most of these are seen as socio-economic situations. Frequently having some sort of spiritual attachment to the one affected by whatever disease or discomfort they may be feeling. Marie must have used the skills passed down by her mother, grandmother, and many others to do the incantations necessary to help those that had been suffering during the Yellow Fever pandemic. While 'witchcraft' was banned during the era of her life, her ties with the elite of New Orleans and the rumors surrounding her must have impacted the reason she was left alone by authorities.

With her career built, she must have eventually realized

that her skills and connections with the white elite of New Orleans would benefit her rumored occultist abilities. It was probably at this time that myths frequented more about how she spent her after-hours. The assumption being that she was doing dark demonic rituals, sacrificing animals, and conjuring forces of evil. The truth is probably much less sinister and evil. She mainly just dealt with personal affairs and offered advice and guidance in her clients' everyday lives. From financial hardships to fertility and love, she was there to comfort and help those in need of her services.

FIVE

Marie's Life as a Priestess

MARIE'S INFAMY STARTED TO GROW AFTER SHE GOT INVOLVED with the elite of New Orleans. More people began to seek her out, and she was known to walk the streets wholly unbothered. Previously frowned upon acts of Voodoo became almost acceptable once she pioneered it into popularity. While this was positive for those of the Voodoo religion, it wasn't as progressive as most people would assume. In a place where any non-Christian belief is forbidden, it turned a traditional and sacred belief into an exotic tourist attraction. Marie brought to light many misconceptions, but unfortunately, she also added to the mystery. While she had many clients, this didn't make most of the rituals she performed acceptable or recognizable. Her specialty was healing and herbal remedies, and perhaps the odd love potion here and there. Beyond these standard practices, she was also still a devout Catholic. This continually makes it difficult to separate myth from fact. As a priestess, a Mambo, she would have been accountable for many spiritual responsibilities.

From mixed sources, it is discovered that a Priestess carries her community on her shoulders. Unfortunately, this heavy burden is necessary in a place that lacks compassion for the

marginalized. A Mambo provides patrons, followers, and innocent citizens with refuge from the trials of life. It is their job to ease the quality of living. The works that a priestess uses are also crucial to the survival of the religion. Since Voodoo is only orally transferred from generation to generation and the Lwa are selective about who they choose to be, the bearer of their stories, knowledge, and a communicator of spirits. It's essential that when a priestess undergoes her patronage to the spiritual arts and creates her connections with the Lwa that she is dedicated and doesn't take the honor bestowed upon her for granted. They need to be willing and open to hearing from Lwa and any other ancestral advice and guidance. After all, this is the preservation of culture and identity. The mambo must be willing to let a spirit take over their body through the rite of dance and rhythmic music. each Lwa is different, each having a personality of its own. These details make or break the cultural history built on the backs of those that came before (Robinson, 2018).

Whether true or not, she was a people's person, and most of her money earned on philanthropy was dedicated to bringing comfort to those in need at her own expense. Beyond just the general communication with the Lwa, ancestors, and spirits, she also helped comfort inmates during their last days. She treated people with Yellow Fever because medicine during that time wasn't easy to procure.

The inmates on death row might not have had much to comfort them, but rest assured, with Marie visiting and bringing them food and remedies and comforting them, they at least had an easier time. There were rumors that she helped inmates commit suicide instead of being hanged. Still, those were just propagated by the media at the time. After all, a woman of color with a high status attending to men on death row? It painted her as a woman ahead of her time in social activism (Press, 2020).

Her daughter, Marie Philomene Galpion, lamented once

that she wished people stopped focusing on her mother's Voodoo practices. She hoped they would instead notice the personal missionary journey she participated in to ease the suffering of her community and its people (Press, 2020).

Marie Laveau, often painted and accepted as an unofficial saint in modern-day spirituality, wasn't squeaky clean, though. She owned her own fair share of slaves. Whether this was due to her husband or because she had intended for them to buy their freedom from her, it is unclear. But it is a fact that shouldn't be overlooked. All history is important (Alvarado, 2020).

If you do know anything about Voodoo, you'd frequently see a picture of Marie with a snake around her neck. It's said that her snake was named Zombi and was a representation of the Supreme God. She is often depicted dancing with him, on certain nights, deep into the evening, when the streets were quiet and her white, French clients didn't walk the streets. She and a troupe would go down to a lake and perform the more rigorous and severe rituals. Due to her connections, she was one of the very few priestesses allowed to perform these rites. In a way, you can assume that she had two faces: a performer and consultant and that of her true heritage (Vitelli, 2012).

There aren't too many sources on Marie's clients or endorsed her exploits as a Voodoo Priestess, but she clearly impacted the city. From standing by the side of condemned men to uplifting her community during a pandemic, she was a force to be reckoned with. While her impact was small during that era, she still made a difference, and it only made the legend stronger. Perhaps it wasn't just her Voodoo that had people enamored with her, but also her enormous compassion for people and those around her.

SIX

Marie Laveau's Followers

It can be practically indisputable that Marie has gathered quite the following, both during the 17th century and moving through time and history to the 21st century. It's not just practitioners of Voodoo that believe in her, but also many other branches of spiritualism. Horror enthusiasts and tourists from all around the world enjoy a good story about the Queen of Voodoo. She is often depicted as more than just a woman who lived a very long time ago. Numerous blogs speculate about her life and analyze the resources available to them. Marie Laveau will always be the enigma, and perhaps that is how she wanted it. Why else would she not have written about herself? She left her literary life in the hands of second-hand accounts and only her daughter's commentary on her life (Wilson, 2007).

Marie's followers rarely depict her as normal. Instead, she is shown to be a feminine entity who embodies empowerment and strength. A Saint in some cases and others a spiritual advocate and communicator between the realm of the unseen and that of the physical world. Some of her followers spread the legend that she never truly died and that she is still alive and out in the world. They go as far as to say that her daugh-

ter, whose resemblance to her mother was uncanny, was Marie Laveau herself. This is not hard to believe after even American Horror Story played on this premise in their Coven season. Either way, during her time on earth, she was known to be a voice of influence. Some sources state that she drew in women of color into her dancing rituals and white women whose husbands and family might have perished during the American Civil War. Things such as child-bearing, money, love, or even just to bring good fortune are some of the things her followers sought after. Today, it can be simply accomplished by the infamous "Wishing Ritual," which will be explored in just a few moments (Wishing Ritual, n.d.).

With this large following and amassed populace of people behind her, it was common courtesy to at the very least respect her. She and her following of locals most likely contributed to why law enforcement turned the other way as she danced in the street. It's unclear whether there were copy-cats. Fast-forwarding into these modern times, you will see that the people who worship her legacy are those looking for a spiritual guide and assistance in trances that take one into different planes of existence. Many books even cover and elaborate ways to make contact with, or conjure, if you will, the spirit of Marie. She has become well-respected and even honored. In some beliefs, she is recognized as an Orisha, which is the Voodoo term for a powerful being sent by the Supreme God to provide a safety net in the spiritual realm. Most of the time, they are depicted as female. Her followers are loyal, her life was impactful—but what about the day she died, and what is the actual legacy she left behind?

Death, Legacy, and What She Left Behind

A LEGACY IS AN IMPORTANT, FUSSY THING—IT MAKES OR breaks your entire history, and sometimes it can be the victim of slander. In Marie's case, it is a sort of saved-in-time tourist attraction. It's sad. Here is a woman who dedicated her life to serving the community. She is turned into a tour guide's repetitive speech. On June 15, 1881, Marie Laveau died on St. Ann's Street, where her cottage was located. She was surrounded by family and friends, and her death was kept private and small. She was then placed in St. Louis cemetery, near her unofficial husband, Galpoin, who had died in 1855. He was said to have been her last partner as she did not take anyone else. He was young when he died, but he loved her, and although dedicated to her job, I think Galpoin is still and will always have been enamored by Marie.

She left behind two daughters when she died, and one of them continued to do her mother's work. So much so that people confused the two and assumed Marie Philomene Galpoin was her mother. Which is untrue. Marie might have continued her mother's legacy. Still, she also allegedly contributed to spreading the truth about her mother beyond the rumors and Voodoo rituals. She wanted people to know

her mother for her works that contributed to her community and helped uplift the downtrodden.

Besides leaving behind her daughters, Marie also left behind a new and improved understanding of Voodoo. While it by no means removed the shackles of misrepresentation, it improved the views of the belief for many people. It helped boost Voodoo in modern-day society and developed at least a tolerance to the practice that wasn't there previously. All this and more have contributed to the tourist attraction that New Orleans has garnered. The result of that is the fascination with Voodoo objects of interest. The next chapter will deal with the many assortments of things used by Voodoo priests and the myths around their uses. Hopefully, the stereotypes perpetuated by Marie can be unpacked and the actual benefits explored.

Voodoo Amulets, Dolls, and More

REGARDLESS OF MARIE'S LEGACY, THERE ARE STILL unanswered questions about her life, and one of those is what tools and means she would have used? While official records are few and far between, one can, through research in the commonly sought Voodoo objects, garner quite easily what she might have used. In the next chapter and subchapter, we will unpack just the sort of products and significant objects she might have employed during her career and the significance of those in Voodoo. After all, who would say no to any additional information and facts (Handloff, 1982)?

Gris-Gris and Amulets of Power

A gris-gris, sometimes known as a grigri, is an object that most Voodoo practitioners craft for their patrons. This talisman or amulet has its origins out of Africa and is designed and crafted for various uses. It is commonly created to ward off evil or as just essential protection against anything classified as a spiritual attack on a person. However, this isn't its only use since, in the more western area of Africa, they can be used for birth control. The practice of wearing a gris-gris was surprisingly

used by believers and non-believers alike. Its appearance, while varied, was usually a small cloth bag inscribed with African verses that contained small ritualistic objects. Allegedly, it was also used in the Islamic faith as protection against evil spirits called Djinn. In Haiti, they are seen as objects of good fortune used to improve the external lives of the wearers and imbued with some sort of incantation. New Orleans has its version of a gris-gris. While they may be inaccurately represented as a form of black magic, they are, in fact, a much more positive item in the arsenal of Voodoo objects. Unlike the belief that it was designed to bring ill-will on patrons' enemies, records indicate people tampering with other's amulets as a form of vengeance. It is believed that, in actuality, the gris-gris was just sources of healing and protection. Why would its original meaning change so much in the course of Voodoo history? Many believed Marie used these talismans to curse people, but odds are, she simply used them to improve the way of life of those around her. After all, a woman who comforted prisoners before their deaths and attended church every Sunday couldn't have used such a thing for evil and rarely did other Voodoo priests and priestesses (Handloff, 1982).

The Infamous Voodoo Doll

As portrayed in modern media, the idea of a Voodoo doll is simply a doll or a figurine representing a person in one's life. It is then created by using personal objects with attachments to said person (for example, hair) and then using the doll to enact all kinds of spiritual acts (Beyer, 2019). The most popular acts that people associate with Voodoo dolls are that of vengeance and mayhem. In western media, it's often shown that people with hate towards another person create the doll to hurt and curse people instead of what the dolls are initially intended for. Once a staple of West African traditionalism and Haitian

beliefs, it is now reduced to nothing more than a tourist novelty in New Orleans. Voodoo Dolls have a terrible reputation. It is always depicted in popular media as a small, stitched-up doll that you imbue with your enemy's essence. It then uses a needle prick, causing pain and inconvenience. And while it's not unheard of that the dolls are used for curses, it's doubtful that they are commonly used for this purpose (Original Botanica Products, 2015).

The process of making the dolls has nothing to do with stitches and stuffing. Instead, the dolls are customarily made from sticks, straws, or any personal and organic material of the people that you'd like represented in the image of the figurine. As with West African spirituality, they are physical representations of the spiritual realm around people. Taking place on altars and surrounded by objects of interest. It's a form of respect and remembrance, much like an ofrenda or altar, that people of Mexican descent use on the Day of the Dead to honor their lost ones and ancestors. These physical conduits to family, friends, and loved ones are there to bring connection with that of the Lwa and to leave prayers and petitions of goodwill unto those that people are close to. It might be fun to purchase a Voodoo doll in New Orleans when visiting the city but remember, there is a difference between a souvenir and an object of spiritual importance (WikiHow Contributors, 2021).

Voodoo Potions

All through the ages, potions and medicinal concoctions were used as a means to ease pain and suffering, as well as coupled with deadly poisons. Marie used her herbalistic abilities to create potions that helped to relieve the suffering of the sick. But she could have also made potions that tackled the complexities of love. Voodoo uses many different kinds of potions for many various reasons. Still, the most sought-after and popular potion is the Love potion. Everyone dreams of

their fairytale story, and it was no different for the citizens of New Orleans. The love potion is there to bring lovers who have fought back together or help the patrons of unrequited love entrance their targets so that they can have that love returned. The secrets of the ingredients have been a mystery and likely is something only revealed through oral tradition.

Additionally, poisons were also developed, things that could cause severe pain in the gut or even be silent killers. Briefly mentioned early, it's another rumor that followed Marie around. She poisoned the food brought to prisoners to kill them before they could be hanged. Sort of taking on the role of an Angel of Mercy (Wikipedia Contributors, 2020).

Usually, these potions are more than just magical imbued drinks. But instead, they are likely medicinal concoctions used when instructed so by a spiritual prophet. It's typically made with indigenous plants, and healers usually have experience and extensive knowledge of the properties of the medicinal drinks. Not just anyone is bestowed with the gift of healing (Don, 2021).

Some potions are also made by people often referred to as Root Doctors. As with the nature of the word, root doctors are known to use lots of organic materials. Many potions and concoctions use significant ingredients related to that of the patients seeking help. Some common ingredients used in these potions were nail clippings, indigenous roots of the area. Hair of the person to which the incantation is connected, and many other elements that show up in nature.

I am sure by now, Voodoo is sounding less and less like the terrifying satanic, pagan cult that popular media seemed to portray. Instead, it is more of a helpful community of people participating in their cultural heritage and looking out for one another. Voodoo, however, should not be taken lightly. While many tourists who visit Crescent City enjoy the ghostly tours and stories of Marie Laveau, they should also know that it is 'Buyer's Beware' when it comes to the complexities of

Voodoo. Giving respect to the ancestors is crucial to the well-being of any individual living their daily life. Word of the wise is to make sure that all basics are covered before using any Voodoo object—and constantly educate yourself before trying anything.

NINE

Her Rivals and Other Voodoo Priests

KEEPING ALL OF THE PREVIOUS CHAPTERS IN MIND, WHICH ARE mainly informational overviews of the nature of Voodoo and the practices surrounding it, it is time to deviate and look at other figureheads that spearheaded the religion of Voodoo into modern society and helped build its very foundation (Lewis, 2019a).

The lovely Marie Laveau isn't the only protagonist in the history of Voodoo, but instead a mere drop in the ocean of figures and icons that created the complex world of Voodoo. Often, they were all rivals or inspirational influencers of their time. Who more to admire and appreciate than that of Dutty Boukman, the first icon who we will explore in this incoming sub-chapter.

Dutty Boukman

Before Marie Laveau, there lived a man named Dutty Boukman, and he was what one would call a houngan. A houngan is a male practitioner and priest of Voodoo. Boukman was originally enslaved in Jamaica before he was transported and left in Haiti. His significance garners a book of its own, but

since this is Marie's limelight, a quick biography is in order. Boukman was a present-day Senegal-born, self-taught slave. Early in his life, he displayed an apparent and justified distaste to the oppressors owning New Orleans. Like Marie, his heart lies with the people and not with those that are the oppressors. He was a key figure in the Haitian Uprising. While he was not the first, his sacrifice alongside fellow priests, Cecelia Fatimann, helped urge other slaves to take up the mantle and fight against injustice. On August 22, 1791, he climbed to the top of a nearby mountain and invoked his ancestors to assist in destroying the white regime of the time. He argued that the "God of the oppressors" is not a god worth following; they teach peace and equality but not against the very blatant contribution to the suffering of his people (Boukman Academy, n.d.).

He performed his ritual alongside Cecelia, and they became the driving force of the revolution. Sadly, his victory and inspired rebellion against the French government became his ultimate undoing as he was captured and beheaded by guillotine. His head was used as an example, a failed attempt to incite fear, but all it caused was more disarray. Eventually, thanks to Boukman, the tension broke, and his fellow slaves fought for their freedom (Staff Writers, 2015).

Sanité Dédé

While Marie Laveau is the Queen of Voodoo, she was allegedly far from the first queen to roam the streets of New Orleans. Very little is known about Sanite Dede. Some say she was the mentor of Marie Laveau. Others say she was an unsuspected rival who got her crown usurped by Marie. However, what is known is that she bought her freedom as a person of color and then became a mentor to children. Sanité seemed as kind as Marie. Whether she was her mentor or

rival, it is perhaps fitting that she was preceded by the most loved Queen of Voodoo (Lewis, 2019a).

Rosalie

Besides Sanité, there was also the woman who tried and failed to dethrone the Queen of Voodoo. She challenged Marie's Voodoo prowess and allegedly placed an African carved statue of some sort out on her yard as a way to ward off Marie. While there isn't much substantial proof of any of these transpired rumors, it is mentioned that Marie had ended up stealing the statue as a way to prevent the Creole woman from creating a following against her. This allegedly also had a court case involved (Lewis, 2019a).

Dr. John

The last figure on our list, but not the least Voodoo practitioner by any means, is the elusive conman, Dr. John. He was another ex-slave that mainly worked with fortune-telling and gris-gris creations. He amassed quite the fortune, and following, unfortunately, that didn't mean much as his distrust in banks and numerous wives eventually bankrupted him. Ultimately, he died alone in poverty. Just like Sanité, it is said he was Marie's mentor, and she preceded him, but these are all just tall tales unfounded in fact.

Petitioning and Forming a Bond With Marie Laveau

WHAT DOES IT MEAN TO PETITION, AND WHY DO PEOPLE participate in the practice? A petition is an appeal to a deity or higher spiritual being. As briefly touched upon in the previous chapter, spiritual interactions are vital to the ecosystem of Voodoo. Each entity has its own personality, likes, and dislikes. Before anyone can begin to think of invoking an entity, they must first understand said entity. Numerous people revere Marie Laveau as that higher being, an Orisha. An Orisha, as previously stated, is a spiritual being bestowed the honor of being a gateway and communicator between the Lwa and the petitioner. You can ask them for small favors, and if you're lucky, it will be granted. In Marie's case, however, it's not just practitioners of Voodoo that invoke her spirit but many people from all across the world. People from numerous religions petition their respective deities, especially those in the Catholic faith, which seamlessly ties in with the syncretic relationship it has with Voodoo. Unlike prayers, which direct communication with deities, petitions are specifically used to ask something exclusively from a god, spirit, or entity; it is to summon an entity with a clear motive.

There is a myth on how to petition Marie Laveau that

involves her grave and a superstitious ritual that tourists and enthusiasts of the supernatural participate in. It is almost traditional for people to visit the final resting place of Marie Laveau and do this ritual. While there are quite a few variations, the basic concept of the 'Wishing Ritual' tradition remains the same. It is said that to get Marie's attention, one must partake in the following steps.

Step One: Approach the tomb of Marie Laveau. Make sure that you are using clear and direct intent when approaching her tomb/grave.

Step Two: Provide an acknowledgment of her power and significance. Give her the respect she so justly deserves. Nothing can sour a relationship between spirit and patron, such as disrespect and lack of knowledge in the divine arts.

Step Three: Knock on the tomb's base three times, or as done in the past, draw with red brick, charcoal, or chalk, three Xs. While no one is quite sure why it's these specific instructions, it is the legend that stayed and stuck around for hundreds of years.

Step Four: Petition or declare your wish and want from the Voodoo Queen. Again, be clear with intent and make sure, since Marie is known for compassion and protection, that your request is in relation to her personality and history. Not just any request or petition will be granted.

Step Five: After performing the above steps, take a trek and go to the Saint Louis Cathedral and light a candle. While not fully explored in the book, Candles are said to be a light or conduit for spirits who are in the invisible realm separate from our own.

Even if there are many different ways to perform the ritual, the above five steps are the most consistent with the myth and ritual. If your wish or petition is granted by Marie, it is essential to return to her tomb and provide her with an offering. It can be anything from food to flowers. As long as

you offer her gratitude and acknowledge the request given (Wishing Ritual, n.d.).

The Benevolent Queen Spell

We will forever know Marie Laveau as an influential woman. Still, individuals don't gather to her grave to offer tribute to an almighty witch. They appear to her in death for the same reason they arrived at her in life. Marie Laveau was generous with her abilities. She helped the needy, women, slaves, and she helped the wealthy, too. Everyone who came to her was looked upon the same.

This spell is a tribute to Marie Laveau and petitions for her intercession with an issue.

Items Needed:
White candle
Black candle
1 Green chili pepper
Red lipstick
A piece of gold
An offering of your choosing (such as 7 pieces of silver, 7 dimes, cigars, etc.)
A prayer card of Marie Laveau
A snake charm or drawing

Directions:
Begin by setting up an altar for Marie Laveau. Place the white and black candles next to each other with your prayer card upright against them. Light the candles. Position the chili pepper next to the black candle, while the snake charm will go alongside the white candle. Place the piece of gold before the prayer card. Your offering will be right in front of you, between the offering and the altar. When you're centered, use the lipstick to draw three X's on whatever surface you're working on. Note: It's best to work on a smooth surface that can be clean easily.

Chant this spell three times. While you do, push your offering over the three X's.

"Dearest Marie, who reigns supreme,
Beyond the iron gates of New Orleans.
Accept my gift, if you will.
And grant my wish, Ainsi soit il."

Vandalism and Desecration of Marie's Final Resting Place.

Many people argue that despite the decade-old ritual of petitioning Marie Laveau by her tomb, it is considered vandalism. Years and years of tourists making their marks on her tomb have brought you into disrepair. Since there are no official Voodoo records on whether or not this superstitious ritual is actually in everyday practice, it is best to assume that it is nothing more than an urban legend.

In addition to the devastating effects of tourists leaving behind litter and showing zero respect for the dead, it is not unexpected to hear that in 2013 an unknown party painted the entirety of Marie's tomb with pink latex paint. The vandalism was discovered by a tour guide and officials on December 17, 2013, and would have taken months to restore. The latex paint used trapped moisture and was very damaging to the historic structure. It couldn't simply be washed off, and using a paint stripper was out of the question. Another unfortunate fact about this vandalism was that the offender also painted the plague white. Despite this, authorities and preservers believe that the intention wasn't malicious. Instead, it was someone who was attempting to cover up the hundreds of Xs left by tourists. These are the consequences of an urban legend. There is doubt whether Marie would have wanted people to use her tomb as a place of ritual or not. This has been disputed since she was a very private and reserved person. No one is even sure where the rumor of the ritual appeared. Perhaps her daughter started the story? There is no

way of knowing. What is clear, however, is that as of recently, the tomb has been closed off to tourists, and any rituals performed will have to be through different means and circumstances. Only a tour guide is allowed to take anyone up close and personal with the tomb of Marie Laveau (Tanya, 2014).

ELEVEN

How to Build an Altar

In regards to rituals, a common practice by Marie Laveau and her followers, and even modern-day practitioners, is to build an altar to honor those departed. To provide oneself with the ability to petition and pray to those who can provide help and advice from the spiritual realm. The importance of an altar can sometimes be overlooked due to contradictory sources and the sheer amount of preparation needed to ensure that the altar is the best conduit for spiritual activity. This, however, should rarely deter followers of Voodoo as the use of an altar is vital to the external workings of the practice. For example, without a clear connection and properly established relationship with the ancestors, the necessary information needed in everyday life will become difficult to conjure up, and charms, such as previously mentioned gris-gris, will lose their potency. But let's not get off track here. To build an altar, whether your entity is the ancestors of your immediate past, or Marie Laveau herself, is a personal endeavor. Think of the altar as not only a conduit but a connection created through the barrier of the spiritual realm and our realm. You want to provide a space to pray and petition with respect and the intention to receive guidance.

Here are some steps that can be followed to create a space of spiritual connection, but a disclaimer is in order. This is purely from the sources cited and general advice on the nature of altar worship and practice. In no way is this the spiritual law of altar creation (Elias, 2019).

Step One:

Find a place in your home that has minimum foot traffic. You'll want the altar to remain undisturbed by any household presence to create the best space for the spirits that will be entering through the barrier of the invisible. Try not to put the altar in your bedroom unless you have a cut-off area, as the altar will be ripe with spiritual interactions. You wouldn't want to create a space that can interrupt your sleep.

Step Two:

Set up a table or surface made from organic materials. Preferably, it should be wood, as natural as possible, but glass is also acceptable, according to some. You'll then want to cover that table or surface with a cloth. While a cloth isn't 100% necessary, it helps add to the care and personalization of the altar. Try using cotton, and stay away from synthetic material.

Step Three:

Place a book of spiritual significance on your altar, something that connects you with your ancestors. While it's not set in stone, many people who practice Voodoo use a Bible since the chances of their ancestors having Catholic beliefs in their past lives are quite high. Do note that there should be an established relationship with the spirits and ancestors. Every piece added should be approved by the entities you are trying to appeal to.

Step Four:

Add candles. Candles are a waypoint for spirits. It is like a light shining out into the darkness to draw them closer and to help guide them to your altar. It's highly recommended to keep your candles stocked up and use more than one. The

more candles, the better chance you have of attracting the right spirits. It is also suggested to use a white candle, for each color represents something different.

Step Five:

Place a personal item or one of significance to the spirit, deity, or ancestor on the altar. Something that attracts the correct being you'd like to honor or petition. This can be a family heirloom, a picture, or something favored by the spirit. This is to make sure that no other sort of random spirits breakthrough.

Step Six:

Place offerings. This can be from food or objects of value to beverages. Some popular choices are coffee, bread, or even rum. Another thing to add to your altar is something that signifies the importance of human life. Water is a good choice since it represents birth, rebirth, and death in numerous cultures and is nearly non-perishable. It is necessary to switch out your offerings at least once a week.

Step Seven:

While it's not necessary, consider adding an offering to a protector or guardian spirit. This can be a Saint, or some even invoke the Virgin Mary. If you want Marie to be that spirit, add some incense that would be appealing to her. It is good to have a guardian spirit as additional help for communication and protection against any malevolent spirits hanging around. It's a small price to pay, and it's also good to already have an established bond with your invoked guardian.

Step Eight:

Once you've got your altar set up, it is time for the most critical part of its existence—to contact the spiritual realm and seek their advice. It is important to be open and respectful of the advice provided.

More Ceremonies

Altars and objects of power and interest—the imaginings of Voodoo knows no bounds. Not only do the people who practice the religion exude intense energy, but they also create an air of electric spiritual meaning. Ceremonies are, essential and in addition to creating an Altar, it seems it couldn't hurt to understand the rituals that go alongside it.

Imagine for a moment, you're in a crowd, standing on the edge of the circle as people lift their arms up into the air, praying and petitioning whichever entity needs to be summoned and hosted. The ceremony performed is that of cultural significance. Soon after saying a Roman Catholic prayer, drums start to beat, and people begin to dance. It gets faster and faster while the people dance, and the priest provides his offering to the Lwa. They start to convulse as the spirit enters the body. The person is being 'ridden' by a spirit, a great honor.

The priest has his chance to take hold of the situation. He brings forth a manifestation of spirit he holds within him and uses the Lwa to speak to the crowd and offer guidance amongst them (Guynup, 2004).

This is a typical ceremony held either near a temple, town square or on special occasions. In this above scenario, it was just hopefully showcasing the ritual followed in showing respect and accepting a spiritual being into the space of existence. While this is in no way the only ceremony available to the Voodoo belief, it is, in fact, one of the most popular used ceremonies. Other additional information to add could be that in Voodoo, they use offerings of all kinds and, if led by a spirit, the sacrifice of animals, generally small ones like chickens. Never are humans used in a sacrifice. Even if this is so, this myth has been perpetuated for years. It's time to change that (Guynup, 2004).

TWELVE

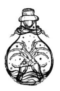

Places of Spiritual Significance and Voodoo Tourist Attractions

I͟t͟'͟s͟ ͟n͟o͟ ͟s͟e͟c͟r͟e͟t͟ ͟t͟h͟a͟t͟ ͟p͟r͟e͟s͟e͟n͟t͟-͟d͟a͟y͟ V͟o͟o͟d͟o͟o͟ ͟h͟a͟s͟ ͟b͟e͟e͟n͟ exploited and misrepresented. Despite Marie's best efforts to improve people's lives, her power as Queen could only stretch so far and so thin. Some places attract tourists like flies. Like Marie's use of hairdressing, many patrons of Voodoo use these places to their full advantage. After all, why not make money based upon the tourist industry in New Orleans? Over the years, from ghost tours to waterfalls, a few places have garnered locals' and tourists' attention (Jacobson, 2016).

Marie Laveau's House of Voodoo

Marie had a daughter who was commonly known as Marie II. While there was some confusion over who did what, it is said that Marie II lived her life to its fullest capacity in the house that is now a museum. Visitors of the house can leave offerings at an altar. Buy Voodoo fetishes and general oddities in the shop at the back and also participate in readings and spell enchantments when there are spots available. This museum and tourist attraction is a must-see for not just any Voodoo

practitioners but also Marie Laveau II history buffs who are looking for a boost in their step.

New Orleans Historic Museum

Founded in 1972 by Charles Massicot Gandolfo, a local artist with a vivid passion for Voodoo. This historical site had been offering numerous services that are tied to the Voodoo world. These include psychic readings and divination appointments. Much like the Marie Laveau Museum, it is also filled with oddities and objects from a time long past. It is a love letter to New Orleans, Voodoo, and Marie Laveau.

Saut-d'Eau Waterfalls

These falls in Haiti are said to bear healing powers because the Virgin Mary had allegedly appeared there and blessed the area. Hundreds of Haitians trek to these waterfalls during Feast day, otherwise known as the Catholic holiday, Saints Day. Here they spend three days celebrating and commemorating the Saints while washing away any ailments in the waterfall. There had been an attempt by a French priest during the eighteenth century to remove a blessed palm tree, a way to curb superstitions. Still, much to his dismay, the entire area was seen as blessed.

Jubilee Voodoo Monument

Another place of spiritual significance in the Voodoo religion of Haiti, the Jubilee Monument, is just another expansion on how the Catholic and Voodoo religion merged together to form an important belief. Believed to have been erected by those of the Catholic faith, a cross is visible on the monument, an alleged attempt to signify God retaking the hill of Ans A Floeur, Haiti. A century later, the cross on the monument was

struck by lightning. Since then, locals believe it's a sign that instead, their deities are reclaiming the land as their own.

Today, it is still used as a place of worship, pilgrimage, and sacrifice.

The Akodessewa Fetish Market

This superstore, a Voudon fetish marketplace in Lomé, Togo, is filled to the brim with amulets, curse objects, and human skulls. All useful objects for incantations and the removal of curses. As the capital city of Togo, Lomé is the perfect place to find and hire a Vodou priest mostly brought up and excelling in the arts of prophecy and aiding in sickness (Jacobson, 2016).

Why list these places at all? Because despite the superstitions, they are cultural beacons, telling stories that the average consumer will never know. A museum, monument, or even a place of spiritual significance gives a person access to the world that is now preserved in these heirlooms and dedications to the past. It excels in maintaining stories and the truth.

It's a reflection of that which once was and still thrives today.

Conclusion

So, this is the end of the journey. Not the final goodbye, as there are now many ideas to explore, and this book only scratched the surface. After all, the destination doesn't have to be the end, especially with Voodoo. It's complex and beautiful, deserving of respect and understanding. I hope this book has elaborated on this and helped expand the reader's knowledge.

The conclusion is by no means the end, but only there to conclude this small metaphorical chapter in the lives of figureheads of Voodoo. The goal of the book was to educate and clear up uncertainties about Marie and her life. The hope was that all the additional information about Voodoo and the key figures was a transformative experience for you, the reader from the Transatlantic Slave Trade travesties and how it had affected the very lives of those who suffered at its hands to the time when New Orleans was but a speck in an ocean of developing cities in the United States. A city finds its feet amidst racial tension and turmoil, only to spearhead itself into merging and expanding diverse cultural identities. These details may not seem important, but they were. With those historical anecdotes, we were able to use them to piece together small bits of information and deduce just the sort of

work and life Marie had. After all, history is crucial to the accurate speculation of a figure shrouded in mystery. Her children, her affairs, and her husbands have kept people on the edge of their seats. Hopefully, there has been a shift in the thought process and understanding for the reader using the information garnered in this book. Delving deep into the legacy of the Voodoo Queen has been an honor and served its purpose while also getting extra. Even some intimate knowledge of West African spirituality, rituals, and traditions used to worship in the respective culture.

Suppose there is only one takeaway from this book. In that case, it is that perseverance and compassion are never in short supply. Like a page from a book, we should never disregard the tangled, complicated, and factual history behind the stories, myths, and legends that make up the figureheads in modern society.

This is a love letter to the life and times of Marie Laveau, the Queen of Voodoo.

References

19th Century Midwives. (2014, June 24). History of American Women. https://www.womenhistoryblog.com/2014/06/19th-century-midwives.html

Anderson, J. E., & University of Florida, G. A. S. L. (2002). Conjure in African-American society. In the Internet Archive. Gainesville, FL,. https://archive.org/stream/conjureinafrican00ande/conjureinafrican00ande_djvu.txt

Anderson, M. (2013, December 11). 19th Century Childbirth | Adelaidia. Adelaidia.history.sa.gov.au. https://adelaidia.history.sa.gov.au/subjects/19th-century-childbirth

Art of the Root. (2013, November 26). Hair: A Hoodoo & Voodoo Ingredient. https://artoftheroot.com/blogs/news/10426109-hair-a-hoodoo-Voodoo-ingredient

Atlas Obscura. (2016, October 10). Marie Laveau's Tomb. Atlas Obscura. https://www.atlasobscura.com/places/marie-laveaus-tomb

Bailey, S. (2018, December 30). America's first pharmacy doubled as a secret Voodoo potion exchange. The Southern Weekend. http://thesouthernweekend.com/secret-Voodoo-potion-exchange/

BBC. (2019). Reasons for the development of the slave trade - Revision 1 - Higher History - BBC Bitesize. BBC Bitesize. https://www.bbc.co.uk/bitesize/guides/z22nfg8/revision/1

Beck, J. J. (2006). Root Doctors | NCpedia. Www.ncpedia.org. https://www.ncpedia.org/root-doctors

Beyer, C. (2019, January 25). What Are Voodoo Dolls and Are They Real? Learn Religions. https://www.learnreligions.com/are- Voodoo-dolls-real-95807

Blumberg, A. (2016, April 28). Inside The Life Of A Vodou Priestess Bringing Healing To Haiti. HuffPost. https://www.huffpost.com/entry/inside-the-life-of-a-vodou-priestess-bringing-healing-to-haiti_n_57225f19e4b01a5eb-de4fe68

Boukman Academy. (n.d.). Who was Dutty Boukman? . Retrieved May 31, 2021, from https://www.boukmanacademy.com/intro-to-the-haitian-revolution/dutty-boukman

Boyd, A. (2019, July 12). St. Louis Cemetery No. 1: Is Marie Laveau where they say she is? NOLA.com. https://www.nola.com/archive/article_25942435-4b6e-5c62-b408-872715db8a21.html

Connerton, W. C. (2012). Midwifery. In Encyclopædia Britannica. https://www.britannica.com/science/midwifery

Craan, A. G. (1988). Toxicologic aspects of Voodoo in Haiti. Biomedical and Environmental Sciences: BES, 1(4), 372–381. https://pubmed.ncbi.nlm.nih.gov/3077265/

Davis, A. (2013, July 19). Drunken midwives and snooty surgeons: a short history of giving birth. The Conversation. https://theconversation.com/drunken-midwives-and-snooty-surgeons-a-short-history-of-giving-birth-16208

Dimuro, G. (2018, March 28). The Real Story Of Marie Laveau, New Orleans' Witchy Voodoo Queen. All That's Interesting; https://allthatsinteresting.com/marie-laveau

Don. (2021, May 1). A Writer's Guide to Potion and Spell

Ingredients Used in Magic. HobbyLark. https://hobbylark.-com/writing/potion-and-spell-ingredients

Dorsey, L. (2021, May 23). A Marie Laveau Mystery Solved ? New Discoveries by LSU Student Kenetha Harrington. Voodoo Universe. https://www.patheos.com/blogs/Voodoouniverse/2021/05/a-marie-laveau-mystery-solved-new-discoveries-by-lsu-student-kenetha-harrington/

Durrell, J. (2017, May 15). Marie Laveau - Voudou Queen of New Orleans. Women's Scribe and Poet; Content Strategy Online. https://justinedurrell.net/marie-laveau-voudou-queen-of-new-orleans/

Elias, S. (2019, March 2). How to Build An Ancestor Altar. Crescent City Conjure. https://crescentcityconjure.us/blogs/city-of-conjure/how-to-build-an-ancestor-altar

Faith healing | Britannica. (2020). In Encyclopædia Britannica. https://www.britannica.com/topic/faith-healing

Forgotten Lives. (2020, November 10). The Real Life of the New Orleans Voodoo Queen | Marie Laveau. Www.youtube.com. https://www.youtube.com/watch?v=WLd1vBtWXHQ

Gonzalez, A. V. (2014). Voudon. Encyclopedia of Psychology and Religion, 1870–1874. https://doi.org/10.1007/978-1-4614-6086-2_9131

Guynup, S. (2004, July 7). Inside the Voodoo Rituals of Haiti. Culture. https://www.nationalgeographic.com/culture/article/haiti-ancient-traditions- Voodoo#:~:text=In%20Haiti%20 Voodoo%20 believers%20pray

Haiti - Climate. (n.d.). Encyclopedia Britannica. Retrieved June 13, 2021, from https://www.britannica.com/place/Haiti/Climate#ref515784

Handloff, R. E. (1982). Prayers, Amulets, and Charms: Health and Social Control. African Studies Review, 25(2/3), 185–194. https://doi.org/10.2307/524216

Herz, M. (2017, October 10). The Day of the Dead

Ofrenda | Inside Mexico. Inside-Mexico.com. https://www.inside-mexico.com/the-day-of-the-dead-ofrenda-2/

History Of New Orleans Voodoo | New Orleans. (2017). Neworleans.com. https://www.neworleans.com/things-to-do/multicultural/traditions/ Voodoo/

Jackson, J. J. (2019). New Orleans - History. In Encyclopædia Britannica. https://www.britannica.com/place/New-Orleans-Louisiana/History

Jacobson, M. M. (2016, October). 9 Sacred and Superstitious Voodoo Sites You Can Visit Today. Atlasobscura. https://www.google.com/amp/s/www.atlasobscura.com/articles/9-sacred-and-superstitious- Voodoo-sites-you-can-visit-today.amp

Jan, C., & Webster. (1990). Haiti: List of Loa. Webster.edu; Compilation of Class assignments. http://faculty.webster.edu/corbetre/haiti/ Voodoo/biglist.htm

Josephine Ozioma, E.-O., & Antoinette Nwamaka Chinwe, O. (2019). Herbal Medicines in African Traditional Medicine. Herbal Medicine. https://doi.org/10.5772/intechopen.80348

Lewis, S. P. (2019a). Marie Laveau - Rivals. In Encyclopædia Britannica. https://www.britannica.com/biography/Marie-Laveau/Rivals

Lewis, S. P. (2019b). Marie Laveau | Biography & Facts. In Encyclopædia Britannica. https://www.britannica.com/biography/Marie-Laveau

Lewis, T. (2018). transatlantic slave trade | History & Facts. In Encyclopædia Britannica. https://www.britannica.com/topic/transatlantic-slave-trade

Louisiana State University. (2021). PhD Student Kenetha Harrington Collaborates on Archaeological Survey Studying Black Freedom Fighters. Lsu.edu. https://www.lsu.edu/ga/news/2021/03/woodland_plantation.php

Marie Laveau Voodoo Queen Of New Orleans

www.hauntedneworleanstours.com. (2011). Hauntednewor-leanstours.com. http://www.hauntedneworleanstours.-com/marielaveau/marielaveau/

McAlister, E. A. (2018). Vodou | Definition & Facts. In Encyclopædia Britannica. https://www.britannica.-com/topic/Vodou

NHT. (n.d.). New Orleans Cemetery Tour | Historic New Orleans Tours. NOLA Historic Tours. Retrieved May 24, 2021, from https://www.tourneworleans.com/walking-tours/cemetery/

NicGriogha, B. (2019, February 1). Mythical Ireland | Myths & Legends | Brigid, Bright Goddess of the Gael. Mythical Ireland | New Light on the Ancient Past. https://mythicalireland.com/myths-and-legends/brigid-bright-goddess-of-the-gael/#:~:text=Brigid%20is%20the%20Daughter%20of

Nittle, N. (2020, October 30). "We're reclaiming these traditions": Black women embrace the spiritual realm. NBC News. https://www.nbcnews.com/news/nbcblk/we-re-reclaiming-these-traditions-black-women-embrace-spiritual-realm-n1245488

NPS. (2015, October 22). LEGBA - Guardian of the Crossroads - African Burial Ground National Monument (U.S. National Park Service). Www.nps.gov. https://www.nps.-gov/afbg/learn/historyculture/legba.htm

Nunn, N. (2008). Chapter 5. Shackled to the Past: The Causes and Consequences of Africa's Slave Trades. https://scholar.harvard.e-du/files/nunn/files/hup_africa_slave_trade10.pdf

Original Botanica Products. (2015, July 28). How Do Voodoo Dolls Actually Work? . https://www.originalbotani-ca.com/blog/ Voodoo-dolls-rituals-spells/

Overdeep, M. (2021, May 25). 200 Years After He Disap-peared, LSU Student Believes She's Found Voodoo Queen Marie Laveau's Husband. Southern Living. https://www.-

southernliving.com/travel/louisiana/marie-laveau- Voodoo-new-orleans-husband-jacques-paris-kenetha-harrington

Press, G. (2020, March 30). Marie Laveau: First Pagan Prison Ministry. https://gullveigpress.wordpress.com/2020/03/30/marie-laveau-first-pagan-prison-ministry/

Radford, B. (2013, October 30). Voodoo: Facts About Misunderstood Religion. Live Science; https://www.livescience.com/40803- Voodoo-facts.html

Robinson, K. K. (2018, March 28). Marie Laveau. GoNOLA.com. https://gonola.com/things-to-do-in-new-orleans/history/nola-history-legacy-of-marie-laveau

SCAS. (2019, April 22). SCAS 2019 Conference Now Open for Registration. http://scas.org.uk/wp-content/pages/Voodoo-love-spells.html

Semester At Sea. (n.d.). Traditions of Healing: Voodoo & Alternative Medicine. Retrieved June 13, 2021, from https://www.semesteratsea.org/field-programs/traditions-of-healing- Voodoo-alternative-medicine-sp20/

Staff Writers. (2015, August 14). Dutty Boukman (Boukman Dutty), a slave who escaped from Jamaica, led a rebellion in Haiti. Jamaicans.com. https://jamaicans.com/on-this-day-in-jamaican-history-dutty-boukman-boukman-dutty/

Tanya, M. (2014, February 4). Vandalism or Voodoo? The Mausoleum of Marie Laveau. The Funeral Law Blog. https://funerallaw.typepad.com/blog/2014/04/vandalism-or- Voodoo-the-mausoleum-of-marie-laveau.html

Tempe De La Luna. (n.d.). Being a Mambo – Temple de la Luna. Templedelaluna.com. Retrieved May 30, 2021, from https://templedelaluna.com/being-a-mambo/

The Editors of Encyclopaedia Britannica. (2021, March 3). Jean-Baptiste Le Moyne de Bienville | French explorer. Encyclopedia Britannica. https://www.britannica.com/biography/Jean-Baptiste-Le-Moyne-de-Bienville

The Editors of Encyclopedia Britannica. (2018). slave

trade | Definition, History, & Facts. In Encyclopædia Britannica. https://www.britannica.com/topic/slave-trade

Times-Picayune, M. S., NOLA com | The. (2018, February 13). Marie Laveau: Separating fact from fiction about New Orleans' Voodoo queen. NOLA.com. https://www.nola.com/300/article_b68b1247-169a-5164-a399-9e73bbc732fd.html

Times-Picayune, R. A. W., NOLA com | The. (2013, December 31). Repair of Marie Laveau's tomb to take months, potential suspect attempted to paint another tomb one month ago. NOLA.com. https://www.nola.com/news/crime_police/article_fece97ca-f32a-522d-a4f0-0a4ae0ca8904.html

Upshaw, G. (2019). Marie Laveau. Ghost City Tours; Ghost City Tours. https://ghostcitytours.com/new-orleans/marie-laveau/

Vitelli, R. (2012, January 3). The Marie Laveau Phenomenon. Archive.randi.org. http://archive.randi.org/site/index.php/swift-blog/1572-the-marie-laveau-phenomenon.html

What Can You Learn From Marie Laveau About Magic? — The https://thetravelingwitch.com/blog/what-can-you-learn-from-marie-laveau-about-magic

Wigington, P. (2018, January 10). Honoring Brighid, the Hearth Goddess of Ireland. Learn Religions. https://www.learnreligions.com/brighid-hearth-goddess-of-ireland-2561958

Wigington, P. (2019a, September 28). Who Is Papa Legba? History and Legends. Learn Religions. https://www.learnreligions.com/papa-legba-4771384

Wigington, P. (2019b, October 3). The 8 Most Important Voodoo Gods. Learn Religions. https://www.learnreligions.com/ Voodoo-gods-4771674

Wiki Contributors. (n.d.-a). Historica Fandom Dutty

References

Boukman. Historica Wiki. Retrieved June 13, 2021, from https://historica.fandom.com/wiki/Dutty_Boukman

Wiki Contributors. (n.d.-b). Marie Laveau. American Horror Story Wiki. Retrieved May 31, 2021, from https://americanhorrorstory.fandom.-com/wiki/Marie_Laveau#:~:text=Marie%20Laveau%20is%20the%20legendary

WikiHow Contributors. (2021, May 25). How to Use a Voodoo Doll. WikiHow. https://www.wikihow.com/Use-a-Voodoo-Doll

Wikipedia Contributors. (2019, November 22). West African Vodun. Wikipedia; Wikimedia Foundation. https://en.wikipedia.org/wiki/West_African_Vodun

Wikipedia Contributors. (2020, January 6). Mambo (Vodou). Wikipedia; Wikimedia Foundation. https://en.wikipedia.org/wiki/Mambo_(Vodou)

Wikipedia Contributors. (2021a, May 26). Dutty Boukman. Wikipedia. https://en.wikipedia.org/wiki/Dutty_Boukman

Wikipedia Contributors. (2021b, June 3). Louisiana Voodoo. Wikipedia. https://en.wikipedi-a.org/wiki/Louisiana_ Voodoo#Prominent_figures

Wikipedia Contributors. (2021c, June 6). Papa Legba. Wikipedia. https://en.wikipedia.org/wiki/Papa_Leg-ba#:~:text=Papa%20Legba%20is%20a%20Ginen

Wilson, T. V. (2007, February 16). How Voodoo Works. HowStuffWorks. https://people.howstuffworks.com/Voodoo.htm

Wishing Ritual. (n.d.). Www.marie-Laveaux.com. Retrieved June 13, 2021, from https://www.marie-laveaux.-com/wishing-ritual.html

writer, D. M. | S. (2021, May 22). Marie Laveau's husband disappeared 200 years ago, but an LSU student thinks she finally found him. NOLA.com. https://www.nola.-

com/entertainment_life/article_1dfbca9c-ba4b-11eb-87a4-330e11b1b903.html

Yale University. (2019). Hispaniola | Genocide Studies Program. Yale.edu.

Alvarado, D. (2020). The Magic of Marie Laveau : Embracing the Spiritual Legacy of the Voodoo Queen of New Orleans (). Weiser Books.

About the Author

Monique Joiner Siedlak is a writer, witch, and warrior on a mission to awaken people to their greatest potential through the power of storytelling infused with mysticism, modern paganism, and new age spirituality. At the young age of 12, she began rigorously studying the fascinating philosophy of Wicca. By the time she was 20, she was self-initiated into the craft, and hasn't looked back ever since. To this day, she has authored over 50 books pertaining to the magick and mysteries of life.

To find out more about Monique Joiner Siedlak artistically, spiritually, and personally, feel free to visit her **official website**.

www.mojosiedlak.com

f facebook.com/mojosiedlak

𝕏 twitter.com/mojosiedlak

◉ instagram.com/mojosiedlak

℗ pinterest.com/mojosiedlak

BB bookbub.com/authors/monique-joiner-siedlak

More Books by Monique

Practical Magick
Wiccan Basics
Candle Magick
Wiccan Spells
Love Spells
Abundance Spells
Herb Magick
Moon Magick
Creating Your Own Spells
Gypsy Magic
Protection Magick
Celtic Magick
Shamanic Magick
Crystal Magic

Divination Magic for Beginners
Divination with Runes: A Beginner's Guide to Rune Casting
Divination with Diloggún: A Beginner's Guide to Diloggún and Obi

Spiritual Growth and Personal Development
Creative Visualization
Astral Projection for Beginners
Meditation for Beginners
Reiki for Beginners
Manifesting With the Law of Attraction
Being an Empath Today
Communicating with Your Spirit Guides
Healing Your Inner Child: A Guide into Shadow Work

Get a Handle on Life
Stress Management
Get a Handle on Anxiety
Get a Handle on Depression
Get a Handle on Procrastination

The Yoga Collective
Yoga for Beginners
Yoga for Stress
Yoga for Back Pain
Yoga for Weight Loss
Yoga for Flexibility
Yoga for Advanced Beginners
Yoga for Fitness
Yoga for Runners
Yoga for Energy
Yoga for Your Sex Life
Yoga to Beat Depression and Anxiety
Yoga for Menstruation
Yoga to Detox Your Body
Yoga to Tone Your Body

A Natural Beautiful You
Creating Your Own Body Butter

Creating Your Own Body Scrub
Creating Your Own Body Spray

THANK YOU FOR READING MY BOOK! I REALLY APPRECIATE ALL OF YOUR FEEDBACK AND I LOVE TO HEAR WHAT YOU HAVE TO SAY. PLEASE LEAVE YOUR REVIEW AT YOUR FAVORITE RETAILER!

Milton Keynes UK
Ingram Content Group UK Ltd.
UKHW021301251023
431314UK00026B/951